T0083490

LÁSZLÓ MOHOLY-NAGY

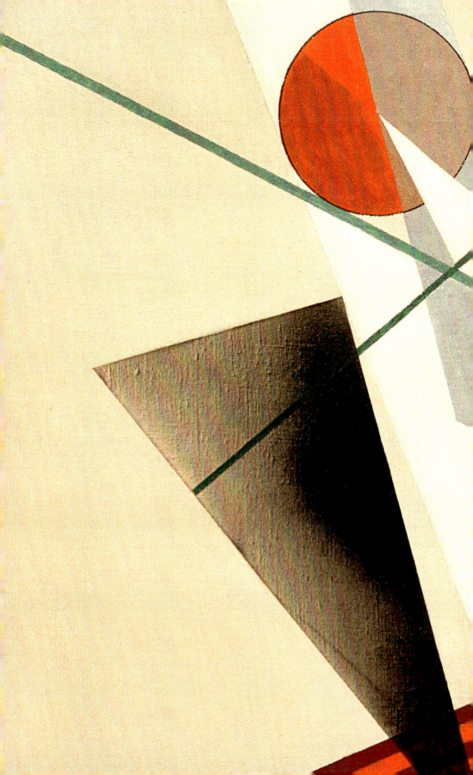

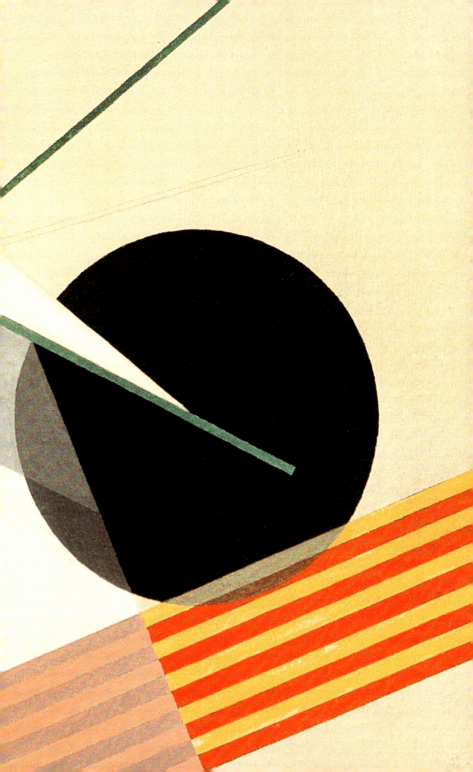

LÁSZLÓ
MOHOLY-NAGY

Hans-Michael Koetzle

HIRMER

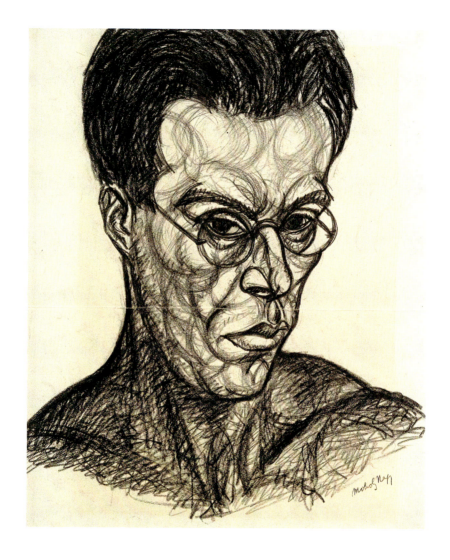

LÁSZLÓ MOHOLY-NAGY

Self-Portrait, 1919/20, crayon on paper
Hattula Moholy-Nagy Collection, Ann Arbor, Michigan, USA

CONTENTS

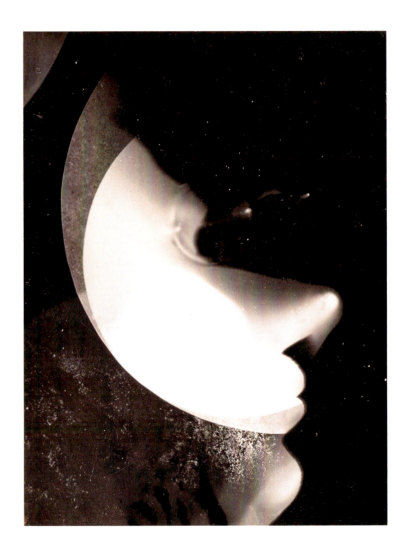

1 Untitled (Self-Portrait), 1926, photogram, silver gelatin print
Fotografische Sammlung Museum Folkwang, Essen

"THIS CENTURY BELONGS TO LIGHT" LÁSZLÓ MOHOLY-NAGY AS MULTIPLE VISIONARY

Hans-Michael Koetzle

László Moholy-Nagy (1895–1946) undoubtedly numbers among the outstanding artistic personalities of the first half of the 20th century. Even his contemporaries noticed the impetuous genius of this self-taught artist who painted, drew, photographed and was seemingly omnipresent in the media. Herbert Read, for example, described him in 1935 as "one of the most creative intelligences of our time",[1] a judgement accepted unreservedly by the subsequent historical reception. He was praised as a "Leonardo of the 20th century",[2] a "Renaissance artist",[3] an "artistic multi-talent",[4] a "key figure"[5] in inter-war Germany in respect to the emancipation of photography as an art form: "Probably the single most influential promoter of the New Vision in 1920s Germany."[6] Avant-garde is a favourite term used to describe the creative explosion in the years after the First World War. The young László Moholy-Nagy was a well-networked part of this controversial, resolutely international roster of artists – and here too remarkably ground-breaking: "A modernist who is so far ahead that he is almost out of sight."[7]

Moholy-Nagy always defined himself simply as a "painter". A "strange self-description", as Andreas Haus, one of the most famous experts on his photographic oeuvre, notes.[8] Yet aside from the fact that apart from a few interruptions Moholy-Nagy painted throughout his life and was engaged with aspects of panel painting: for the Hungarian artist the engagement with pigments was nothing less than the starting point for incessantly new, fundamental questions relating to the question of seeing, of perception, of light and space, of how people moved in a world increasingly dominated by technology. There was hardly a field or a challenge in the free or applied arts of those years, moreover, that Moholy-Nagy did not explore. With the curiosity and open-mindedness of a child, the indefatigable amateur hurled himself into every imaginable means of expression, often simultaneously, and always accompanied by intensive reflection.

Moholy-Nagy revolutionised the photograph in its aesthetic possibilities, explored camera-less photography as an artistic and didactic medium, was active in the field of typography, designed books and catalogues, and contributed vital impulses to experimental film. His name is closely linked with the techniques of photomontage and collage – in connection with the advertising that was emerging at that time. Terms such as "typo-photo", "new typography", or "photogram" were coined by him, or at least have become established in the wake of his essays, lectures and teaching. Moholy-Nagy worked in the theatre and in stage design, decorated shop windows, experimented with new materials such as aluminium and a variety of plastics, and made sculptures and kinetic objects that could be said to have anticipated "Ars Electronica". "He developed an abundance of new ideas," asserted Walter Gropius, his life-long mentor, without the scope of his activities "fragmenting the powers of the painter Moholy; no, all his successful efforts […] were ultimately only necessary detours on his path to conquering a new space in painting. Here is where I see his key significance. Painting remained his great passion."[9]

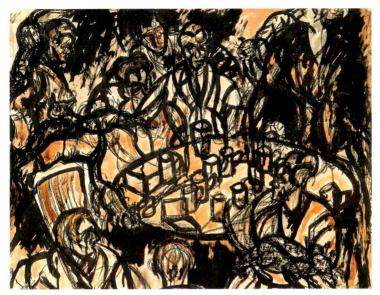

2 *Tafelrunde [Group at Table]*, 1919, watercolour and ink on paper
Private collection, Hannover

ONE OF THE BEST WRITERS ON ART

His artistic practice in the above-mentioned fields was accompanied by a broad, unflagging, permanently committed engagement with publicising issues around art, art education and society that was highly regarded by contemporaries. A "writing mania"[10] would hardly be the right word, yet we could call it a certain fixation with theory resembling the driving force which obsessed many other artists of the time – Wassily Kandinsky springs to mind. Moholy-Nagy did not construct a hermetic edifice of ideas, did not formulate an "art theory", but rather an "artist theory",[11] which in the long term has proven enduring and significant not despite, but precisely because of its imaginative eclecticism. His publications are regarded as having set standards in the world of art and in the world of the media, the latter a term crucial for his thinking. Moholy-Nagy persistently saw and promoted art under the aspect of communication. Regarding himself as a Constructivist, he was concerned with impact. Reproducibility proved not

Moholy Nagy 20

3 *F in Feld [F in Field]*,
1920, collage and
watercolour on paper
Private collection

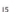

to be a defect; on the contrary, for him the new aesthetic could and should derive precisely from new technologies. This is an aspect that makes his thought topical in times of digital transformation.

Theory and practice always went hand in hand for Moholy-Nagy. Theory was neither a preceding instruction for action nor a subsequent justification for new steps on aesthetic terrain, but rather a fundamental desire for an intellectual foundation for his activity. An essay entitled "Production – Reproduction" was published for the first time in 1922 in *De Stijl*, a key journal for the dissemination of Constructivist ideas, and can be regarded as the beginning of his publishing activity. This activity ends with a brilliant summary of his thinking, activity and teaching, published posthumously in 1947 under the title *Vision in Motion* and sometimes regarded as his "pedagogical testament".[12] In between lay frequently quoted declarations, such as his statement entitled "Die beispiellose Fotografie", published in 1927 in the yearbook *Das Deutsche Lichtbild*, in which he clearly distances himself from Albert Renger-Patzsch and the New Objectivity.

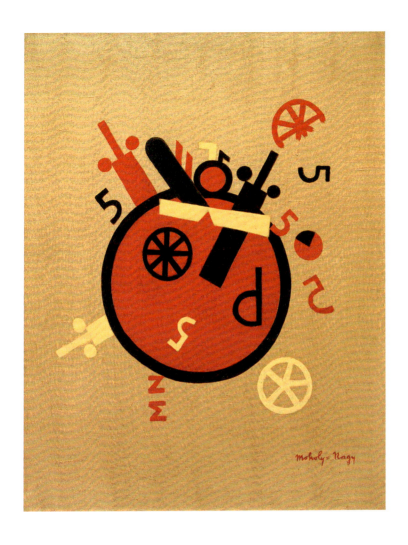

4 *Grosses Rad (Große Gefühlsmaschine) [The Great Wheel (Large Emotion Machine)],*
1920–21, oil on canvas, Stedelijk van Abbemuseum, Eindhoven

"This century belongs to light," he states, "Photography is the first form of light design, albeit – or perhaps for precisely this reason – in transposed and almost abstract form."[13] In fact, his texts not only appeared in isolated avant-garde journals such as *Broom*, *MA*, *Der Sturm*, *Mécano* and *i10*, which were certainly indispensable for the exchange between artists at the time, or in well-established specialist journals such as *Photographische Korrespondenz* and the high-circulation *Agfa Photoblätter*, but also as contributions to catalogues or in popular cultural magazines such as *Schünemanns Monatshefte*, which literally carried Moholy's revolutionary thoughts into bourgeois drawing rooms and thus ensured that his name became the epitome of artistic awakening in these circles as well. Richard Kostelanetz tracked down this "Mine of Perceptions" and made it accessible in the form of a reader which, as the editor emphasises, impressively confirms "Moholy's talent as one of the very best writers on modern art."[14]

FUNDAMENTAL INVOLVEMENT WITH LIGHT

The ever-active Moholy-Nagy has been associated until today mainly with the Bauhaus in Weimar and Dessau. This occurred although he only taught at the school for five years. Moreover he was the youngest among the masters there, and still had to prove himself in comparison to celebrated figures such as Paul Klee, Gerhard Marcks, Wassily Kandinsky, Lyonel Feininger and Oskar Schlemmer. Yet Moholy stormed "into the Bauhaus circle" like "a powerful, eager dog",[15] as his pupil, the later photographer Paul Citroen, recalled. Together with the dominant impression he made from the beginning this must have not only made him friends. In any case, Moholy's appointment to the Bauhaus by Walter Gropius in 1923 marked a paradigmatic change in the history of the institution. With him the expressive craftwork phase ended and what Wulf Herzogenrath describes as the "early production phase emphasising the formal and Constructivist" aspects began.[16] Specifically, Moholy-Nagy revamped the preliminary course founded by Johannes Itten and modernised the metal workshop he was put in charge of. He never taught photography there, as is often claimed. Yet he set off a veritable photo-boom with his eagerness to experiment with the camera as well as with his programmatic book *Malerei Photographie Film*, published in 1925 and translated in 1969 as *Painting*

Photography Film, long before a photography class was introduced at the Bauhaus in 1929 and providing a flood of documentation of everyday life at the Bauhaus. More important and more decisive for the establishment of the "Bauhaus brand" was Moholy's typographic activity, beginning with the catalogue for the first Bauhaus exhibition in 1923, extending to the pioneering *Bauhausbücher*, and including all kinds of printed materials and brochures. They conveyed an uncompromisingly modern appearance, established a kind of corporate identity, and marked a crucial path for the so-called New Typography.

From Constructivist-inspired panel painting to photography and photogram, light sculpture and stage design: Moholy-Nagy was concerned in his artistic production not with the reproduction of reality in whatever form, with decoration or illustration, but with a fundamental examination of light. How early, how much this phenomenon preoccupied him is demonstrated by a programmatic poem he composed in 1917, while still in Hungary, that begins with the call to the reader: "Discover the light years of your life…". This "creed", as Sibyl Moholy-Nagy called this early ode,[17] defined his literary path. Yet it was probably only the move to Berlin in 1920 that made him aware of the consequences of this declaration and of its phenomenological dimension. That very year Berlin not only became a true metropolis, "Greater Berlin" – also in name – with the incorporation of individual city districts. It was also indisputably a city of light and of electricity, with its advanced street lighting, impressive neon signs in some spots, and its numerous windows illuminated at night, which transformed the familiar panoramas into their negative. Not to be forgotten was the powerful electro-technical industry, which Moholy-Nagy would indeed subsequently work with: his *Light-Space Modulator*, displayed for the first time at the Paris Werkbund Exhibition in 1930, would never have become reality without the cooperation of AEG (fig. 12).

ART AS AN INDIRECT TEACHING METHOD

Technology had taken over the world, according to Moholy-Nagy, and one of the fundamental questions for him was how people were to orient themselves in an environment shaped by increasing speed, traffic, vertical movement and an altogether dizzying everyday life. Moholy focused

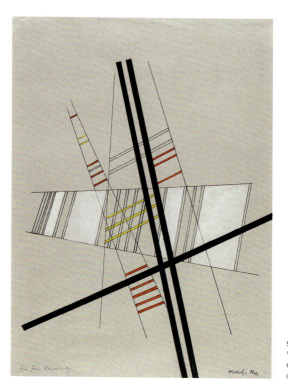

5 Untitled, 1922
Watercolour, ink
Centre Pompidou-
CNAC-MNAM, Paris

precisely on this issue, assigning an educational task to art: that of sharpening the senses, raising human perception to the level of a ceaseless technologisation of the world that was indeed welcomed in principle by the artist. Art for him "functioned as an indirect teaching method, which sharpens the human senses and protects them from all possible assault, indeed, with intuitive safety, as a preventive measure for a situation that has not yet arrived, but surely will."[18] Moholy-Nagy organised his artistic production on the basis of this idealistic, not to say utopian, formula, prominently asserted in the last of the fourteen *Bauhaus* books, *von material zu architektur* (1929; published in English as *the new vision – abstract of an artist*), but also his experimental teaching in Weimar, Dessau and Chicago, where he was less concerned with training in the traditional sense of craftwork than with the expansion of perceptive skills. "The human, not the object, is the goal",[19] he declared in his teaching programme,

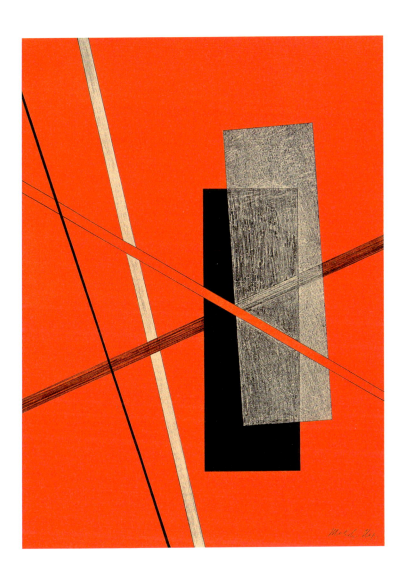

6 *Konstruktion [Construction]* (page 1 for the Kestner Portfolio no. 6,
Hannover 1923), ca. 1922, lithography, Deutsche Bank Collection

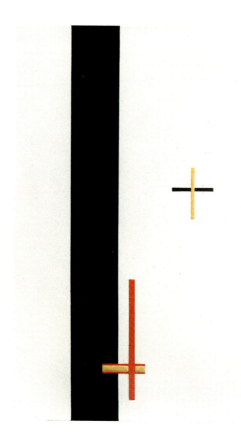

7 *Telephonbild Em 2*
[Telephone Picture Em2], 1922
Enamel and steel, gift of
Philip Johnson in memory of
Sibyl Moholy-Nagy, Museum
of Modern Art, New York

which at its core was the attempt "to comprehensively sensitise the individual, to arouse their skills, and to train these skills as tools, with which to realise a successful life design".[20]

Moholy-Nagy's "conception of the totality of the arts, his desire to overcome their fragmentation and hierarchical structure, his faith in the possibilities of the emergent industrial culture and in the fact that the difference between art and not-art, between craftsmanship and industrial production would become obsolete [...], his striving to replace the archaic notion of the artist as genius with the ideal of the total artist – all this makes him a personality of fundamental significance in the first half of the 20th century", to quote Oliva María Rubio.[21] One could add that he left a further legacy as a teacher and educator, and via his students, who included

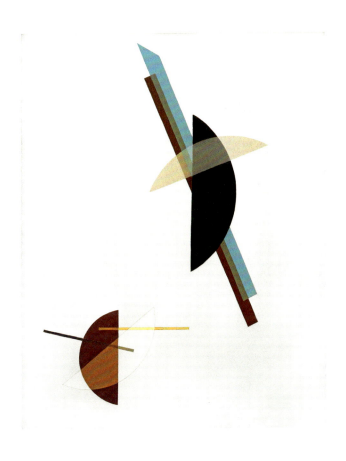

8 *Auf weißem Grund [On White Ground]*, 1923, oil on canvas, gift of
Walter Franz, Cologne 1962, Museum Ludwig, Cologne

such important names such as Gertrud Arndt, Marianne Brandt, Hin Bredendieck, Florence Henri, T. Lux Feininger and Xanti Schwawinsky, as well as Nathan Lerner and Arthur Siegel in the United States.

Moholy-Nagy's educational mission as well as his multi-faceted work must be read against the background of turbulent times. Eric Hobsbawm spoke astutely of an "age of extremes",[22] comprising the First World War, the collapse of the old Habsburg monarchy, the crisis-shaken Weimar Republic just as much as the momentous years of Nazi dictatorship, the Second World War, and the almost complete eradication of European Jewish culture. Budapest, Vienna, Berlin, Weimar and Dessau, and again Berlin are the geographical sites of Moholy-Nagy's fast-paced life, followed by Amsterdam, London and Chicago, where he died a naturalised US citizen in 1946. The artist did not always change places, languages and cultures of his own free will. The end of his period at the Bauhaus and the escape from

Hitler's Germany were turning points that also had economic consequences. He was never well-off, but even periods of existential need seem not to have slowed his zest for action. Moholy-Nagy is described as a naïve optimist,[23] generally conciliatory, but uncompromising and determined where his ideas were concerned. Beaumont Newhall describes him as a "warm-hearted character",[24] Gropius speaks of an "expansive nature", who "often did not allow others to get a word in."[25] In contrast, Werner David Feist recalls a teacher who spent a lot of time with "young students in talks and discussion in the cafeteria", who "was very accessible".[26] "He was a stimulating mentality", declared the president of the Parker Pen Company after Moholy's death.[27] In short, a universal thinker, who "like few others knew how to inspire others with his enthusiasm."[28] Although he wrote and published so much, he revealed very little of a personal nature in his texts. He left this role posthumously for Lucia Moholy,[29] his first

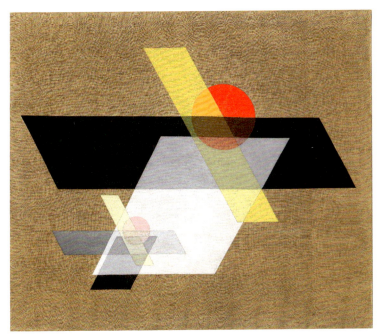

10 *A II*, 1924, oil on canvas, The Solomon R. Guggenheim Museum, New York

9 *Die Mechanik des Lichtrequisits [The Mechanics of the Lighting Prop]*, 1922–30, watercolour, ink, pencil on circular cut-out paper, mounted on hardboard, Bauhaus-Archiv, Berlin

wife, and Sibyl Moholy-Nagy,[30] his second. The latter has reported a re-
markable sentence, almost a legacy: "I don't know yet about my paintings",
Moholy is supposed to have said to one of his closest assistants shortly
before his death, "but I'm proud of my life."[31]

AN IMPASSIONED LEARNER AND A DREAMER

The question has already been posed within the framework of an exhibi-
tion and its catalogue: How is it that such a small country like Hungary has
produced so many artist photographers of international stature?[32] Names
like Brassaï, André Kertész, Martin Munkácsi and Robert Capa are perma-
nently etched on the world map of photography. But it also includes
photographers such as François Kollar, Lucien Hervé, André de Dienes,
Dennis Gabor, Gyula Pap, Károly Escher, the animal photographer Ylla
and the renowned photo-journalists Stefan Lorant and Andor Kraszna-
Krausz. Not to forget Ergy (actually Erzsébet) Landau. She allegedly

11 *Fotogramm [Photogram]*, 1922, silver gelatin print
Metropolitan Museum of Art, New York

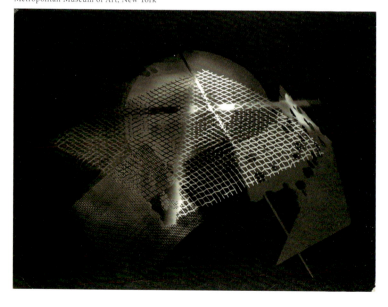

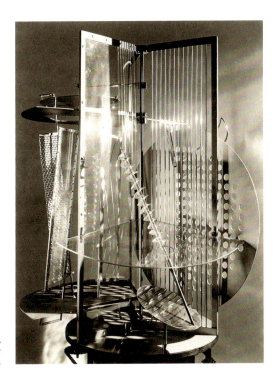

12 *Light Space Modulator,*
1922–30, Busch-Reisinger
Museum, Cambridge, MA

encouraged Moholy-Nagy in 1919 to purchase an Ernemann 6.5 × 9 cm camera.[33] László Weisz, however, did not find art and culture in his cradle when he was born in Borsod (later Bácsborsód) in 1895. His father Lipót Weisz is supposed to "have gambled away the large wheat farms in the south of the country" and "escaped to America".[34] An uncle, Dr Gusztáv Nagy, a bachelor barrister and fairly well-off, was prepared to take in the stigmatised remnants of the family in his home in Mohol. His extensive library with Hungarian as well as German and French literature, proved to be a significant stimulus. The young László distinguished himself from his companions early on, drawing as well as writing poems in the style of Sándor Petőfi or János Arany. "He was a quiet child", writes Sibyl Moholy-Nagy, "an impassioned learner and a dreamer, but fiercely determined to do what he had recognised as the best."[35]

László, who in 1909 adopted the surname of his uncle, was considered different, at least gifted. In primary school he received various awards. He

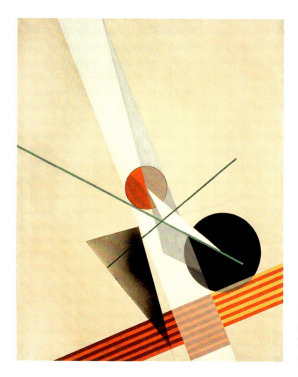

13 *Komposition A XXI. [Composition A XXI.]*, 1925, mixed technique on canvas
Westfälisches Landes-museum, Münster

also published his first texts in newspapers in Szeged. There he completed his *Abitur* [matriculation examination] in 1913, and following the advice of his uncle enrolled in the same year at the university in Budapest to study law. He continued to compose poems and he seems to have cultivated serious literary ambitions until 1917. The outbreak of the First World War interrupted all his university plans. In his second year of studies Moholy-Nagy was conscripted and sent to Galicia and the Russian front. As appalling as the experiences he had there must have been, for Moholy-Nagy they led neither to depression nor to that nihilism or defeatism that can be detected in many of his Dada friends, but rather to an increased, decidedly humanist artistic production, which expressed itself increasingly in drawings. A considerable number of field postcards – no less than 400 are mentioned – have survived,[36] depicting portraits drawn with a quick and sure line and featuring Galician farmers and townspeople, his comrades, injured soldiers and nurses. A series of charcoal sketches evidence the

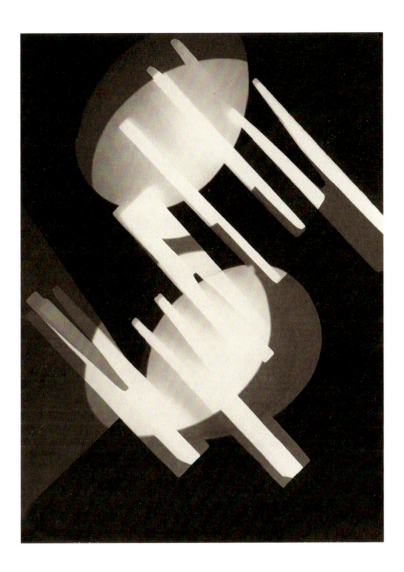

14 Untitled, 1925, photogram, Private collection

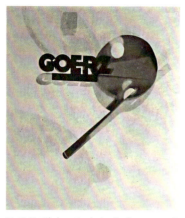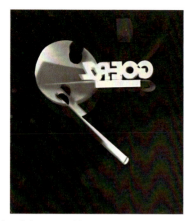

15, 16 Untitled, poster design for Goertz, 1925, laminated photogram with adjacent reverse copy, Bauhaus-Archiv Berlin

influence of the admired Van Gogh, as well as Moholy-Nagy's early struggles with the medium. The scarcity of means certainly led to an intensive exploration of the line, although the results often escaped him, as he later recognised. "The drawings became a rhythmically articulated network of lines, showing not so much objects as my excitement about them."[37]

In no case did he begin as an "abstract painter", as Moholy-Nagy stated in his self-disclosure titled "Abstract of an Artist" and published in 1947.[38] But soon, and encouraged by his Budapest artist friends including Sándor Bortnyik, Iván Hevesy and Lajos Tihanyi, he turned to a non-figurative art adhering to the principles of Constructivism. "He glued coloured strips of paper onto backgrounds in various hues and placed coloured formal elements above or below them. These collages triggered a rhythmical and emotional excitement in him that had not been present previously, when he worked with oil on canvas."[39] In 1917 Moholy-Nagy was seriously injured in the field. This was followed by a stay in a field hospital, convalescence in Odessa, and finally a discharge in September 1918. He continued his law studies, which from the beginning he had pursued with little enthusiasm, until the preliminary examinations. But concurrently to his academic studies he began to make a name for himself as an artist, studying the Old Masters, especially Raphael, Michelangelo and Rembrandt,

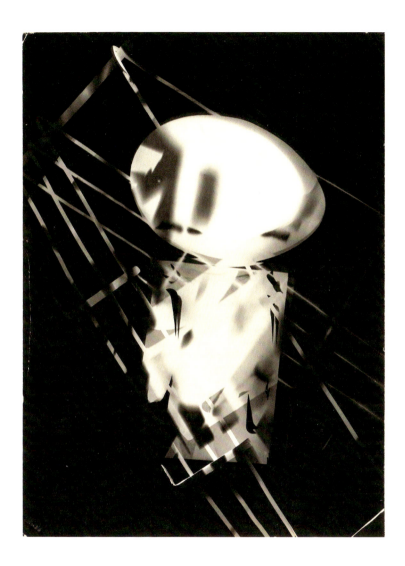

17 Untitled, 1925–28, photogram, Centre Pompidou CNAC-MNAM, Paris

18 *Eifersucht
[Jealousy]*, 1924–27
Silver gelatin print
Victoria & Albert
Museum Collection,
London

attending evening courses at a private art school, and joining the revolu-
tionary group MA (meaning "today") centred around Lajos Kassák. He
was already able to hold his first exhibitions in the National Salon (Nemzeti
Salon) in Budapest and in Szeged, where a group show around the sculptor
Sándor Gergely attracted notice. But the crushing of the Hungarian Soviet
Republic under Sándor Garbai and Béla Kun and the imminent restoration
of Miklós Horthy as Regent signalled the end of revolutionary art in
Hungary. In late November 1919 László Moholy-Nagy emigrated to nearby
Vienna, whose Baroque splendour aroused little enthusiasm. He remained
in the city for approximately six weeks, during which at least the young
Oskar Kokoschka made an impression. At the turn of 1919/1920 he decided
to seek his fortune in Berlin.

19 *Das Weltgebäude [The World Building]*, 1925, silver gelatin print
J. Paul Getty Museum, Los Angeles

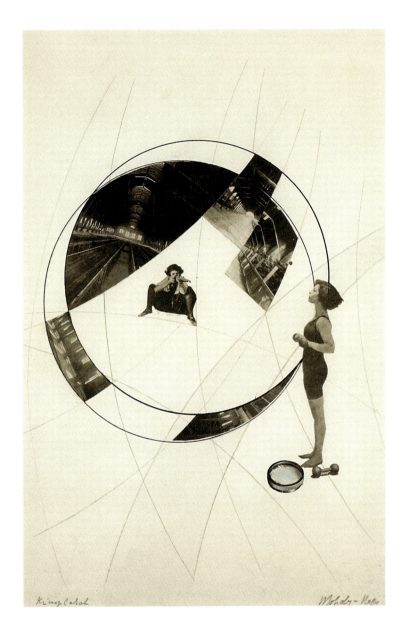

20 *Mord auf den Schienen (Liebe deinen Nächsten)*
[Murder on the Tracks (Love thy Neighbour)], 1925
Silver gelatin print, collage and pencil, Private collection

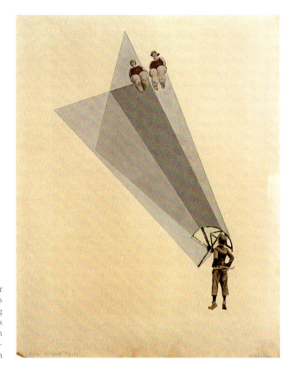

21 *Die Lichter der Stadt
[The City's Lights]*, 1926
Photo-collage using
newspaper clippings
and tempera on
cardboard, Bauhaus-
Archiv, Berlin

A SORT OF SYMBIOTIC TEAM

If the breakdown of civilisation in the First World War, the abrupt collapse
of systems and structures, the inversion of all values led also – and es-
pecially – to an earthquake in the arts, then Germany, and in fact Berlin,
was its epicentre. Faced with a cultural tabula rasa, in the free space of the
young republic, and despite the political and economic problems, a
creative scene was able to establish itself rapidly after 1918 and to profit not
least from the influx of the international avant-garde. László Moholy-Nagy
was not the only Hungarian who chose Berlin. But he was probably the one
who used his opportunity most intensively. Initially he was excited about
the city as a city, its speed, its dynamism, its industrial character. In addi-
tion, Berlin was a media city with book and magazine publishers, photo
agencies and galleries, as well as a lively museum scene. Especially for an
artist interested in technologically-based future forms of expression, Berlin

22 *Oskar Schlemmer*, Ascona 1926, silver gelatin print, Julien Levy Collection, gift of Jean and Julien Levy, The Art Institute of Chicago

must have seemed to be full of promise (in comparison to Haussmann's Paris). We should remember that Moholy arrived in Berlin in January 1920 without a penny and sick with flu. Yet he quickly found friends, kindred spirits, backers, among them the physician Dr Reinhold Schairer, whose portrait in oil crayon on paper executed in 1921 is considered Moholy's last figurative work.

The artist, now aged 25, ceased to keep a diary after 1918. Nonetheless, his surviving works, publications, exhibitions, and not least his artist friends inform us about a career in the German capital launched with resolve from the very beginning. Moholy-Nagy gravitated artistically towards the tendencies of Suprematism, Constructivism and Dada, illuminated by names such as Raoul Hausmann, Hannah Höch, George Grosz and Kurt Schwitters, later joined by the Russians El Lissitzky, Alexander Archipenko and Naum Gabo as well as the Danish experimental filmmaker Viking

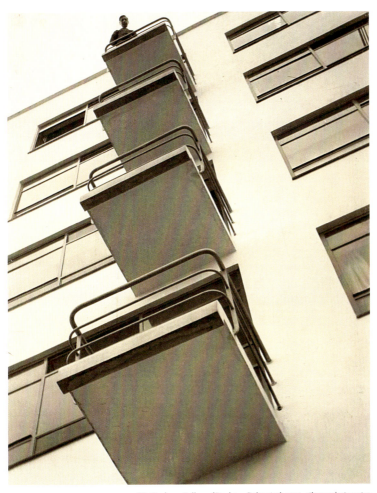

23 *Bauhaus Balkone [Bauhaus Balconies]*, 1926, silver gelatin print
Courtesy of the George Eastman Museum, Rochester

Eggeling. Schwitters in particular proved to be a crucial reference in regard to Moholy-Nagy's turn to typography and collage incorporating photographic components (subsumed under the term "typo-photo"). The Hungarian Moholy, however, did not follow the Berlin Dadaists down their socially-critical and satirical path, adhering instead to a geometrical-rational visual style, for example in his panel painting. In order to

24 *Katze (Negativ-Abzug) [Cat (Negative Print)]*, ca. 1926, silver gelatin print Julien Levy Collection, Special Photography Acquisition Fund, The Art Institute of Chicago

distance or individuate himself in this field, he himself spoke of "photo-sculptures", with his collage on gouache on paper dated 1921, titled *F in Field*, presumably his earliest contribution to this artistic practice (fig. 3).

In the first year of this period in Berlin, Lázló Moholy-Nagy met the young Lucia Schulz, who became his wife the next year. Until their separation in 1929 she was his indispensable intellectual and practical partner. Lucia herself spoke of a "sort of symbiotic team", which provided "the wealth of his sprouting ideas with a fertile breeding ground".[40] After all, she was a university graduate, had attended lectures in philosophy and art history, worked as an editor for publishers such as Kurt Wolff and Ernst Rowohlt, and later acquired solid photographic-technical expertise. As for Moholy-Nagy: he spoke a rather clumsy German and was as unfamiliar with book production as with the "secrets" of the darkroom. In other words: the con-figuration of the *Bauhausbücher*, the genesis of his art-historical texts, is difficult to imagine without the intellectual and practical contribution of Lucia Moholy, although her contribution to the creation of the texts has regularly been disregarded. In her *Marginalien zu Moholy Nagy* she

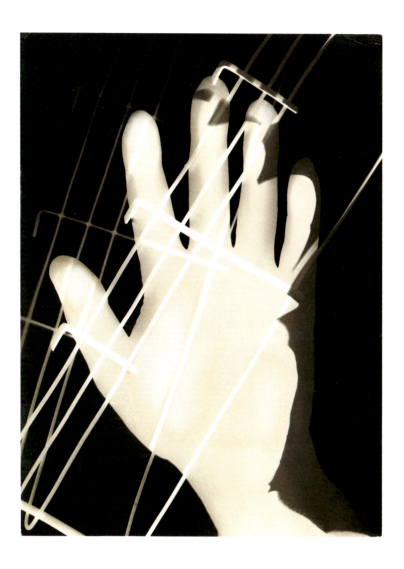

25 Untitled, 1926, silver gelatin print, Ralph M. Parsons Fund,
Los Angeles County Museum of Art

attempted with all modesty to correct this view: "The combination of bold imagination and passionate drive to realise ideas on the one hand and the fundamentally evaluating attitude on the other hand contained in itself the seed of a collective, from which collaborative thinking would become fertile and expand, spurred on by the artist's innate talent. The verbal formulation was usually left to me."[41]

PICTURES OF MAGICAL OPACITY

Moholy-Nagy's adoption of the photogram in 1922 represents a special chapter in his career, not only for his cooperation with Lucia. It is widely known that he did not invent the technique of camera-less photography. Examples of so-called "nature printing" have accompanied the medium since its invention, as an idea and technique stretching back to pre-photographic times. Yet it was Moholy-Nagy who evolved the photogram for art, approximately at the same time as Christian Schad and the Paris-based American artist Man Ray. He coined the descriptive neologism that has become generally accepted, derived from "telegram", attempting repeatedly to define a theory of this form of expression, and recognising not least its enormous educational potential. Whether he first encountered the process at the legendary Constructivist congress in Weimar in 1922, where Tristan Tzara purportedly showed him images from Man Ray's portfolio *Champs Délicieux*, recently published in Paris,[42] or whether he discovered the technique, as one can repeatedly read, while visiting a reform school during an excursion in the Rhön region, is ultimately irrelevant. Moholy-Nagy adopted it quickly – and that was crucial – and placed it at the centre of his artistic efforts in such a manner that we can truly speak of a high-point of his oeuvre.

His struggle with light, his exploration of space, his efforts to sensitise the senses, culminated in the photogram. What began with works on simple daylight copy paper became a never-ending experiment that lasted until his last years in Chicago, with manipulation in the darkroom, the use of developing paper and artificial lighting (so that objects could be illuminated from below). In contrast to Man Ray, Moholy was concerned not with the surreal distortion of recognisable objects, but with their dissolution, in order to achieve amorphous, continually surprising, sublime

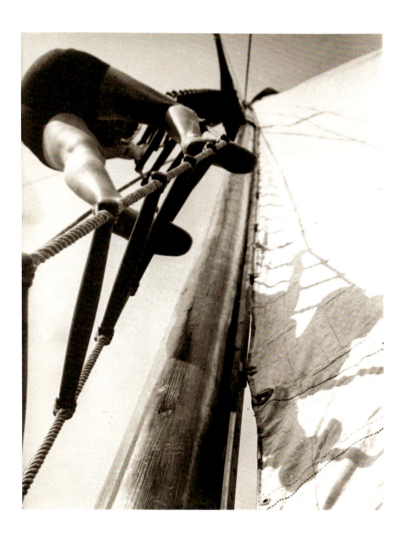

26 *Climbing in the Mast*, 1928, silver gelatin print
The Metropolitan Museum of Art, New York

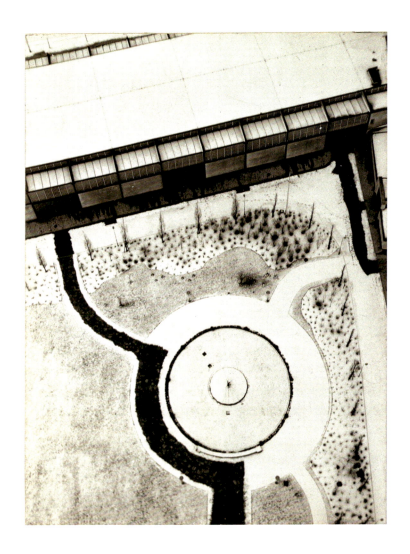

27 *View from the Berlin Radio Tower*, 1928, silver gelatin print
Centre Pompidou CNAC-MNAM, Paris

compositions in black and white. He worked, it is said, by "glazing with light".[43] Herbert Molderings was right to describe the photograms as Moholy-Nagy's "central artistic concern",[44] which can definitely be read as a rejection of "any idea of an engineer's art". His photograms owe "their charm precisely not to the clarity and objectivity of rational constructions – they have nothing in common with the cool, emotionless aesthetic of the technical drawing adored by the Constructivists – but rather to a magical opacity."[45] How important the photogram was to Moholy as a form of expression is proven by the fact that one of his works found its way onto the dust cover of his 1925 book *Malerei Photographie Film* (fig. p. 73) Here he deals with the idea of the photogram only briefly, but all the more extensively in an article published in 1928 in the journal *bauhaus*: "photography is light design", where he writes in the programmatic lower-case mode of the Bauhaus: "the experiments with photograms are of fundamental importance for amateur as well as professional photographers. they provide richer and more important lessons on the meaning of the photographic technique than camera photographs, which are often not very consciously and mechanically made."[46]

Moholy-Nagy swiftly made a name for himself in the Berlin art scene. As early as 1921, a "Call for an Elementarist Art – to the Artists of the World!" published in *De Stijl* quotes him together with Hausmann and Hans Arp. By then his early style with its Expressionist accents had long given way to geometric flat images. He was not alone in this tendency, yet he differed from the metaphysical speculations of the majority of his artist contemporaries in his distinct commitment to reason and technology. The "highpoint of personality-negating objectivity"[47] probably lies in the "telephone pictures" created in this period (fig. 7), industrially produced compositions in enamel made – according to legend – via telephone, which were shown in his third exhibition in 1924 in Herwarth Walden's legendary gallery *Der Sturm*, and which presumably provoked discussion. Walden had first displayed works by Moholy-Nagy in 1922 and it was probably this exhibition of 1924 that Walter Gropius saw, later recalling: "When I first met László Moholy-Nagy in 1922, his art made such a strong impression on me that […] I insisted on his appointment to the Weimar Bauhaus."[48]

The appointment in March 1923 represented a turning point for the Bauhaus as well as for Moholy. For the artist this was his first permanent position, carrying with it the title of "Professor", which he continued to use even after leaving the school. The professorship meant a new social and geographic environment. And it meant the possibility of not making an impact by means of appeals, essays, or pamphlets, but being able to teach directly. Moholy-Nagy was apparently an enthusiastic teacher. With regard to the Bauhaus, founded by Walter Gropius in Weimar in 1919 and initially under the motto of "Art and Craftwork – a New Unity", the appearance of the 27-year-old Moholy-Nagy meant a new conceptual direction. Of course he was young, inexperienced in teaching, and only one more among a troupe of prima donnas with prominent names such as Kandinsky, Klee, Feininger and Schlemmer. Yet he quickly proved to be a "fiery stimulator",[49] an artist who fulfilled "the Bauhaus concept in an ideal manner",[50] as well as one who enjoyed the complete trust of the administration. Not by chance was he soon titled "Gropius' minister president". What Moholy contributed, aside from a reputation preceding him as a Constructivist painter, was a whole-hearted, technophilic optimism in the future. In this

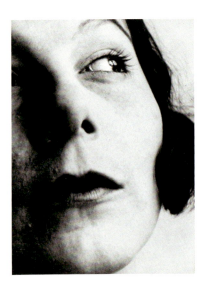

28 *Portrait of Ellen Frank*, ca. 1929, silver gelatin print, Fotografische Sammlung Museum Folkwang, Essen

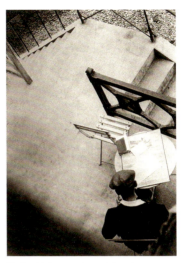

29 *Pont Transbordeau von Marseille [Transporter Bridge in Marseille]*, 1929, silver gelatin print
Spaarnestad Photo Collection, Nationaal Archief, Haarlem

30 *Breakfast*, 1929, silver gelatin print
Collection E. and G. Tatintsian

aspect he was not simply a dogmatic "functionalist and especially not an uncritical devotee of the machine age, but a humanist receptive to technology."[51] For the time being Moholy-Nagy, assisted by the young master Josef Albers, replaced Johannes Itten. The latter was seven years his senior; his preliminary course might have been pioneering for reform school educational practice, but it was accompanied by a sect-like esotericism and proved to be outdated in its orientation towards craftwork, at the latest following the declaration of a new motto. "Art and Technology – a New Unity", which now defined the direction of the second Bauhaus phase. Moholy-Nagy likewise introduced this concept into the metal workshop for which he was responsible. If under Klee's leadership the metal workshop had above all produced "spiritual samovars and intellectual doorknobs", as Xanti Schawinsky jibed, now it was focused on "making devices that satisfied the urgent demand for good models for mass production."[52] An example would be the collection of lighting fixtures developed in co-operation with Marianne Brandt.

With regard to the educational structure of the preliminary course, here Moholy-Nagy clearly followed Itten. "Moholy too was concerned – in the sense of his materialistic worldview – with training not only the optical,

but also haptic sensorial competence. Like Itten he had students combine different materials according to their surface characteristics, although less to explore individual spaces of experience, than to draw up rational and systematic tables."[53] To what degree the Constructivist Moholy-Nagy influenced his students can be seen in the images assembled for his book *von material zu architektur*, published in 1929 as the last of the *Bauhausbücher* series and in some ways a summary of the Bauhaus educational approach. Despite all the cool systematising, a humanism explicitly based on Pestalozzi and Fröbel becomes evident, with the appeal for a "whole person" augmented with those technical aspects that distinguished Moholy from all the other Bauhaus masters. "the solution is thus not against technology," said Moholy-Nagy, "but rather – when one understands it correctly – with it. humans can be freed through it, when they finally know what for."[54]

It is a well-known fact that the Bauhaus was subject to pressure to legitimate itself from the very beginning. The first, almost hastily arranged presentation in late summer 1923 should be seen against this background; its organisation was promptly tasked to the new arrival. Once again Moholy-Nagy saw the challenge as an opportunity to familiarise himself practically with a new field. In the following years, however, he was not only intensively involved in issues of exhibition design. The area of typography, crucial in the course of broad efforts for aesthetic innovation, became a major topic for him. In retrospect, the exhibition and its accompanying catalogue can be regarded as "key events" for the development of "what was later known as 'Bauhaus typography.'"[55]

Moholy employed sans-serif types, asymmetrically laid out double pages, graphic elements to accentuate the argumentation, and "with his brief catalogue entry on 'The New Typography' laid the basis for the programmatic foundation of the movement – and with his essay's title immediately bestowed it with a name as well."[56] On the whole, Moholy-Nagy stood for an external appearance of the school formed according to the principles of an elementary typography, whose aesthetic was naturally to have an impact internally too. Soon Moholy was regarded at the Bauhaus as the "secret typography instructor", although beyond merely teaching he remained stylistically defining for many years afterwards through the design of the first year of the journal *Bauhaus*, through advertising materials and brochures, and above all through the co-editing and design of the highly ambitious

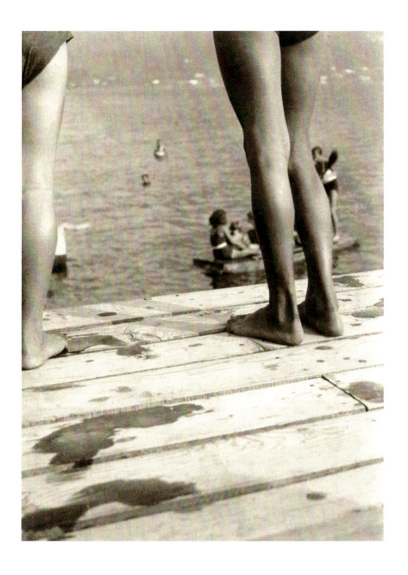

31 *Lago Maggiore*, Ascona, ca. 1930, silver gelatin print
Spaarnestad Photo Collection, Nationaal Archief, Haarlem

series of *Bauhausbücher* launched in 1925. "The *Bauhausbücher* influenced two generations of progressive typographers and designers," emphasises Sibyl Moholy-Nagy, adding a further aspect: what distinguished the titles of the series from all the others was "their function as authentic textbooks, written by the creators of new forms and philosophies and not by the students of their students."[57] New paths in the integration of typography and photography were explored in particular by the eighth book, namely Moholy-Nagy's *Malerei Photographie Film* (re-published in 1927 in a revised edition and with a modernised spelling of the title). Ute Brünig calls it "art work and pamphlet, case study and vision. The book propagates the 'new visual literature' and is at the same time its first attempt."[58]

PROGRAMME FOR A NEW PHOTOGRAPHIC DESIGN APPROACH

Herbert Molderings goes so far as to date "the creation of modern photography" overall to the year of the publication of *Malerei Photographie Film*, even if Moholy had hardly photographed till then.[59] Yet he presented here a programme for a new photographic design approach, authored a kind of "textbook" whose visual grammar of steep views from above and below, negative prints, images of structures and daring cropping of portraits he was in fact to work out in the following years. The preliminary result was the slender volume *60 Fotos* designed by Jan Tschichold and published by Klinkhardt & Biermann (Berlin) in 1930. It included exemplary camera photographs, photograms and photomontages, as well as a foreword by the editor Franz Roh, who underlined from the outset Moholy's "decisive role in the history of the *most recent photography*" (see p. 73). Moholy has, he writes, "worked prolifically in all types of photography."[60] The journal *Kunstblatt* similarly described Moholy-Nagy as a photographer "who has not missed any possibility of today's photographic techniques, responding to all types of stimulation and therefore in turn becoming a stimulator."[61] If we consider his publications in prominent yearbooks of the time such as *Das Deutsche Lichtbild* (Berlin), *Modern Photography* (London) and *AMG Photographie* (Paris), his appearance in the programmatic anthology *foto-auge* (1929) and his participation in international exhibitions such as the show "Modern European Photography" organised by Julien Levy in 1932 in New York,[62] then the impression is confirmed that Moholy, the Construc-

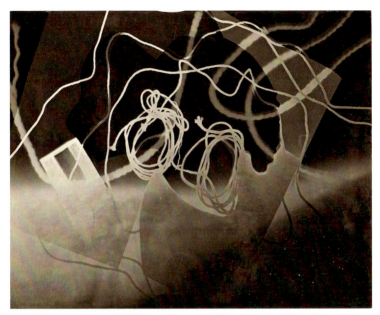

32 Untitled, 1939, photogram, silver gelatin print, Museum Folkwang Essen

tivist painter, was now perceived principally as a photographer: as the leading representative of a "New Vision" in camera art. By this stage he had already long since left the Bauhaus, now based in Dessau.

DEFINITIVE RECORD OF MODERN PHOTOGRAPHY

Moholy followed Walter Gropius, who gave in to political pressure and left the management of the Bauhaus in the hand of the Swiss architect Hannes Meyer. From the very beginning there was disagreement with Meyer, appointed in 1927 as the head of an architecture course. "gro is leaving and i don't want to stay here without him,"[63] wrote Moholy-Nagy to Oskar Schlemmer in January 1928. In his letter of resignation he justified his decision in more detail: "We are at immediate risk of becoming precisely what we as revolutionaries fought against: a professional training school that only values the final product, not the total development of the entire person."[64] At the beginning of 1928 he left the Dessau Bauhaus, followed by

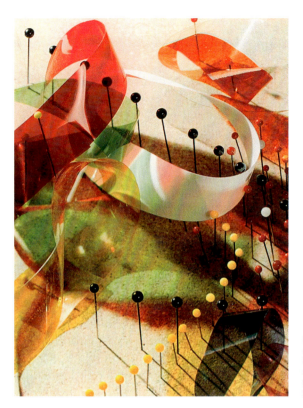

33 *Study with Pins
and Ribbons*, 1937–38
Colour print,
montage, Courtesy
of the George
Eastman Museum

Herbert Bayer, Marcel Breuer and Xanti Schawinsky, and moved to Berlin
for the second time. While in 1920 he had presented himself with letters of
recommendation, now he could feel like an "major figure", not only in the
field of non-figurative painting, but also in the related areas of graphic
design and photography. Indeed, Moholy's second Berlin phase was
entirely devoted to the applied arts, even when he told Will Grohmann
that "now in Berlin" he wanted to become a painter again.[65] In fact, what
he did was make the Bauhaus aesthetic fruitful for everyday life.

Moholy moved into a first studio in the Fredericiastrasse 27 in Berlin-
Charlottenburg, where he was supported – adhering to the Bauhaus ideal
of collective work – by his friend György Kepes and a series of Bauhaus
students such as Hannes Neuner, Hajo Rose and Erich Comeriner. László
Moholy-Nagy was to remain in Berlin for approximately five years before

his forced exile. Once again it was a period that was professionally as well as privately tempestuous, when he separated definitively from Lucia and found a second wife in the actress and filmmaker Sibyl Pietzsch. In between there was brief liaison with Ellen Frank, Gropius's sister-in-law. A boldly cropped portrait of Frank seen slightly from below has found a niche in the history of photography. Franz Roh published it as plate 16 in the above-mentioned book *60 Fotos*, while Jeannine Fiedler set it prominently on the cover of her authoritative catalogue *Fotografie am Bauhaus* (fig. 28).[66]

Moholy took extended trips, visiting Sweden, Norway, and Finland, and he deepened his international contacts, attending the "Congrès International d'Architecture Moderne" and participating in path-breaking exhibitions,

34 *CH Beata I.*, 1939, oil on canvas
The Solomon R. Guggenheim Museum, New York

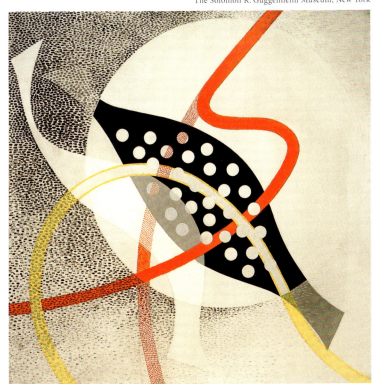

such as the show on photomontages curated by César Domela in 1931 for the Staatliche Kunstbibliothek Berlin. A contribution to the anthology *Gefesselter Blick* (1930) edited by Heinz and Bodo Rasch confirmed his leading position as a representative of typographical Modernism, together with names such as Max Burchartz, Walter Dexel, Kurt Schwitters and El Lissitzky. At the same time he increasingly worked with film, in the sense of experimental light composition. Although his script titled "Dynamik der Großstadt" and published in *Malerei Photographie Film* remained unrealised, it made a name for itself above all as a "masterwork of visual typography".[67] Instead he was able to generate a short film which attracted much attention, *Lichtspiel Schwarz-Weiss-Grau* from "Lichtrequisit", presented in 1930 for the first time. A total of 25 films, film fragments, proposals and film projects are documented from this period in Berlin.

As a designer of sets and costumes for the Kroll Oper and the Piscator theatre in Berlin Moholy-Nagy achieved path-breaking works. The futuristic creations following Constructivist ideals have remained fascinating to this day – subscribing to the motto "if we insist on big opera, then it should be contemporary."[68] (fig. p. 70) In cooperation with Herbert Bayer he developed the typographical concept for the woman's magazine *die neue linie*, launched with great publicity in 1929. A total of ten covers made with collage and spray technique must also be ascribed to his credit, the practical labour confirming his repeatedly stated theoretical affinity to the mass medium of the magazine. Finally, mention must be made of his curatorial contribution to the epochal exhibition "Film und Foto", inaugurated in Stuttgart in 1929, which contemporaries already hailed as "the most important event in the visual area of the last years".[69] Not only did Moholy-Nagy conceive the much-debated introductory Room 1, "Where is Photographic Development Headed", but he also designed the brochure for the "FiFo". He himself was represented in Room 5 with no fewer than 97 works, arranged according to layout principles.

A EXTRAORDINARILY GOOD TEACHER

When Adolf Hitler came to power in January 1933 numerous Jewish, left-wing and avant-garde artists were compelled to leave Germany. A truly distressing summary of the emigration of photographers has been drawn

35 *Nuclear I, CH*, 1945, oil and graphite on canvas, gift of Mary and
Leigh Block, 1947, The Art Institute of Chicago

up by Klaus Honnef and Frank Weyers;[70] among those mentioned is Moholy-Nagy, who was convinced by friends to leave Berlin for Amsterdam in January 1934. The artist apparently did not settle in the Netherlands. Commissions from a printing company and from a silk manufacturer based in Utrecht provided income until the artist was able to move to London with Sibyl and their daughter Hattula in 1935. In this period he purchased a Leica, which allowed him to photograph rapidly and unobtrusively for several books illustrated with photos, such as *Street Markets of London* (1936), *Eton Portrait* (1937) and *An Oxford University Chest* (1938). In addition he designed shop window displays for the exclusive gentlemen's outfitters Simpsons of Piccadilly and a travelling exhibition on wheels (the "Imperial Airways Exhibition Train"). He was commissioned to shoot films, among them the documentary *New Architecture in the London Zoo*, investigated trade fair architecture, worked as graphic designer, and continued to paint, using new, transparent materials. A commission to document the Olympic Games in 1936 in Berlin was rejected by Moholy. Germany, which he had once loved, had become alien for him. A year later he was included with at least one work in the propaganda exhibition "Degenerate Art" inaugurated in Munich.

What was missing was teaching. Moholy-Nagy was unquestionably an enthusiastic as well as a stimulating "evangelist" of his visions. "Moholy", confirms Wilhelm Wagenfeld, "was for me an extraordinarily good teacher and friend, who with the greatest patience focused on each student and exerted his influence on them very gradually and subtly."[71] An unexpected opportunity to regain precisely this aspect of his many talents arose when Walter Gropius, now living in the United States, forwarded to Moholy an enquiry from the Association of Arts and Industries (AAI). The initiative from this interest group, comparable to the German Werkbund, to set up a "design school" according to the Bauhaus model – one year before the major Bauhaus exhibition in New York's MoMA – is seen as the first official evidence of the international attraction that the now historic school radiated. For Moholy the move to the United States and Chicago in September 1937 represented an incredible opportunity. It also marked at the same time the last chapter in his life. Although "the new bauhaus. American School of Design" inaugurated in October 1937 had to close due to financial problems and disagreements with the AAI only one year later, by the end of February 1939 Moholy-Nagy found himself director of a school

once more, thanks to his tenacious efforts. The successor institute, "School of Design", experienced periods of crisis and re-namings before it was ultimately reborn as the "Illinois Institute of Technology". Aside from individual achievements in graphic and product design the school explored new paths educationally. It was the first institution of its kind and in the United States, moreover, the leading training place for artistic photography until the 1960s, with prominent instructors such as Harry Callahan, Aaron Siskind, Henry Holmes Smith and Arthur Siegel. In light of the prominence in that time of *Life* and *Look*, of the Photo League, and the exhibition "The Family of Man", in other words the dominance of photojournalism and documentary photography, it was some time before the "school of Chicago" found recognition in museums. Today its contribution to the "New Vision" in the United States is indisputable. Moholy-Nagy had little time left to teach, to write, and to paint. Less than two years after being diagnosed with cancer he died in Chicago in November 1946. What he left behind was a monumental oeuvre, difficult to subsume under a single category. But this much is true, to quote Sibyl Moholy-Nagy in closing: "Moholy was an utopian who lived in a future world."[72]

HANS-MICHAEL KOETZLE *lives in Munich, where he works as a freelance writer, curator and journalist. Until 2007 he was Editor-in-Chief of the journal* Leica World. *He has published approximately 50 works on the history and aesthetics of photography, including* Die Zeitschrift twen *(1995),* Das Foto: Kunst- und Sammelobjekt *(1997),* Photo Icons *(2003),* Das Lexikon der Fotografen *(2003),* Mack Reporter *(2015) and* René Groebli: Color Work *(2018). In 2004 he curated the retrospective* René Burri *for the Maison Européenne in Paris, and in 2011* Eyes on Paris: Paris im Fotobuch *for the Deichtorhallen in Hamburg. His exhibition* Augen auf! 100 Jahre Leica Fotografie *has been shown in Hamburg, Berlin, Vienna, Porto, Madrid and Rome. The new Ernst Leitz Museum in Wetzlar was inaugurated in 2019 with his exhibition* Dr. Paul Wolff & Tritschler.

1 *L. Moholy-Nagy*, London 1980, p. 11.
2 *Bauhaus. Die Zeitschrift der Stiftung Bauhaus Dessau*, no. 4, 2012, p. 27.
3 Catherine David, *László Moholy-Nagy*, Ostfildern 1991, p. 9.
4 Jeannine Fiedler, *Moholy Album*, Göttingen 2018, p. 16.
5 Van Deren Coke, *Avantgarde Fotografie in Deutschland 1919–1939*, Munich 1982, p. 8.
6 Matthew S. Witkovsky, *Modernity in Central Europe, 1918–1945*, Washington 2007, p. 238.
7 See note 1.
8 Gottfried Jäger/Gudrun Wessing (ed.), *Über Moholy-Nagy*, Bielefeld 1997, p. 139.
9 Gudrun Wessing, *László Moholy-Nagy*, Wiesbaden 2018, pp. 8–9.
10 *L. Moholy-Nagy. Sehen in Bewegung*, Leipzig 2014, p. 3.
11 Andreas Haus, *Moholy-Nagy. Fotos und Fotogramme*, Munich 1978, p. 16.
12 Oliva Maria Rubio (ed.), *László Moholy-Nagy. Kunst des Lichts*, Munich 2010, p. 138.
13 *Das Deutsche Lichtbild. Jahresschau 1927*, Berlin 1927, pp. X–XI.
14 Richard Kostelanetz, *Moholy-Nagy*, London 1971, p. XIII.
15 Sibyl Moholy-Nagy, *Laszlo Moholy-Nagy. Ein Totalexperiment*, Mainz/Berlin 1972, p. 47.
16 Rainer K. Wick, *Das Neue Sehen*, Munich 1991, p. 18.
17 See note 15, p. 24.
18 László Moholy-Nagy, *Von Material zu Architektur* [Reprint of the 1929 edition], Berlin 2019, p. 15.
19 Ibid., p. 14.
20 Ute Eskildsen/Alain Sayag, *László Moholy-Nagy – Fotogramme 1922–1943*, Munich 1996, p. 141.
21 See note 12, p. 11.
22 Eric Hobsbawm, *Das Zeitalter der Extreme*, Munich 1995.
23 Peter Hahn/Lloyd C. Engelbrecht, *50 Jahre New Bauhaus*, Berlin 1987, p. 56.
24 László Moholy-Nagy, *Sehen in Bewegung*, Leipzig 2014, p. 11.
25 See note 9, p. 113.
26 See note 8, p. 46.
27 See note 9, p. 135.
28 See note 8, p. 85.
29 Lucia Moholy, *Marginalien zu Moholy-Nagy*, Krefeld 1972.
30 Sibyl Moholy-Nagy, *Moholy-Nagy. Experiment in Totality*, Cambridge, Mass. 1950.
31 See note 3, p. 9.
32 Károly Kincses, *Photographs Made in Hungary*, Milan 1998.
33 Hans-Dieter Mück, *Auf dem Weg nach Weimar*, Utenbach 2009, p. 115.
34 See note 15, p. 20.
35 Ibid., p. 21.
36 See note 9, p. 13.
37 *The New Vision. Abstract of an Artist*, New York 1947, p. 68.
38 Ibid., p. 67.
39 See note 15, p. 28.
40 See note 8, p. 11.
41 Ibid.
42 See note 3, p. 26.
43 *László Moholy-Nagy. Frühe Photographien*, Berlin 1989, p. 11.
44 See note 20, p. 12.
45 Ibid.
46 *Bauhaus*, vol. 2, 1928, issue 1, p. 2 ff.
47 See note 15, p. 39.
48 See note 33, p. 135.
49 See note 15, p. 9.
50 Wulf Herzogenrath, *László Moholy-Nagy*, Stuttgart 1974, p. 116.
51 Ingrid Pfeiffer/Max Hollein, *László Moholy-Nagy. Retrospektive*, Munich 2009, p. 18.
52 See note 15, p. 45.
53 Jeannine Fiedler/Peter Feierabend (ed.), *Bauhaus*, Potsdam 2013, pp. 369–370.
54 See note 18, p. 13.
55 Patrick Rössler, *Neue Typografien*, Göttingen 2018, p. 28.
56 Ibid.
57 See note 15, p. 44.
58 Manfred Heiting/Roland Jäger (ed.), *Autopsie. Band 1*, Göttingen 2012, p. 164.
59 Herbert Molderings, *Die Moderne der Fotografie*, Hamburg 2008, p. 15.

60 L. Moholy-Nagy, *60 Fotos*, Berlin 1930, pp. 3–4.
61 *Das Kunstblatt*, vol. 15, 1931, issue 4, p. 126.
62 Katherine Ware/Peter Barberie, *Dreaming in Black and White. Photography at the Julien Levy Gallery*, Philadelphia 2006, p. 52.
63 See note 9, p. 81.
64 See note 15, p. 51.
65 See note 9, p. 89.
66 Jeannine Fiedler (ed.), *Fotografie am Bauhaus*, Berlin 1990.
67 Claudia Müller, *Typofoto*, Berlin 1994, p. 89.
68 See note 15, p. 53.
69 Franz Roh, *foto-auge*, Stuttgart 1929, p. 2.
70 Klaus Honnef/Frank Weyers, *Und sie haben Deutschland verlassen … müssen*, Bonn 1997.
71 Walter Scheiffele, *Wilhelm Wagenfeld und die moderne Glasindustrie*, Stuttgart 1994, pp. 216–217.
72 See note 15, p. 11.

36 László Moholy-Nagy, 1926, photo: Lucia Moholy

BIOGRAPHY

László Moholy-Nagy
1895–1946

1895 László Moholy-Nagy is born on 20 July as László Weisz in Borsod (later Bácsborsód), a small village in southern Hungary. He is the second of three sons of the Jewish estate administrator Lipót Weisz (1859–1917) and his wife Karolina, née Stern (1869–1945). After the father leaves the family for the United States in 1897, the mother moves with László and his older brother Jenő (born in 1890) to her parents in Ada (today in Serbia), where the youngest of the three siblings, Ákos, is born.

1898 A maternal uncle, the solicitor Dr Gusztáv Nagy in the nearby town of Mohol (today Mol in Serbia), takes the family in. László (nicknamed Laci) attends primary school in Mohol and Ada. He makes his first drawings.

1905 Moves to Szeged, where László attends the Szegedi Állami Főgimnázium (Szeged State Main Gymnasium) with the financial support of his grandfather and uncle, passing his *Abitur* [matriculation examination] in 1913. He writes poems inspired by Sándor Petőfi and János Arany and publishes in the local newspaper *Szegedi Napló* for the first time in 1912.

1909 László Weisz takes the name of his uncle, prefixing it in 1918 with Moholy, derived from the name of the town Mohol.

1913 Despite his inclinations towards poetry, Moholy-Nagy begins to study law at the Royal Hungarian University in Budapest. He befriends Alfréd Kemény and visits evening courses at the Royal Hungarian National School for Applied Arts.

1915 Moholy-Nagy is conscripted in May at the end of his second year of studies. Even at the front he finds time for drawing. Approximately 400 field postcards illustrated on the reverse with landscapes and occasionally caricatural portraits evidence a self-confident style not without irony.

1917 Moholy-Nagy, now promoted to lieutenant, has his thumb severely injured by shrapnel at the Russian front. After stays in a field hospital and convalescence he is discharged from the Austro-Hungarian army in September 1918.

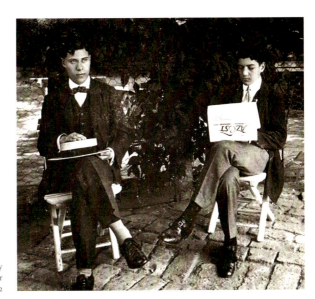

37 László Moholy-Nagy
and his younger brother
Ákos in Szeged, 1912

38 Dadaists and Constructivists in Weimar, September 1922
Upper row, third and fourth from right: László Moholy-Nagy and Lucia Moholy

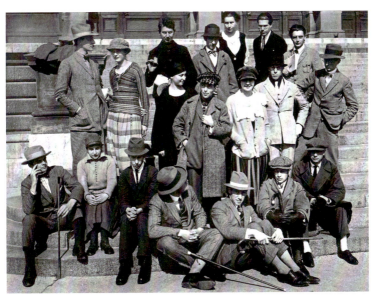

1918 He gives up his law studies, which he has pursued only half-heartedly, as well as his literary plans, in order to focus on painting. He takes courses in nude drawing, studies the Old Masters (Raphael, Michelangelo, Rembrandt), and begins to explore Expressionism and Russian avant-garde art.

1919 After the fall of the Hungarian Soviet Republic Moholy-Nagy leaves the country. He spends six unproductive weeks in Vienna and moves on to Berlin, arriving at the beginning of 1920, impoverished and seriously ill with influenza.

1920 In Berlin Moholy-Nagy quickly makes important and crucial acquaintances, especially with the Dadaists (Schwitters, Höch, Hausmann). Influenced by Russian Constructivism, particularly the works of El Lissitzky, he turns to non-figurative painting and the systematic exploration of space and colour. His collage over gouache on paper, *F in Field* (fig. 3) can be regarded as the first example of the collage technique developed by Cubism.

1921 On 18 January Moholy-Nagy marries Lucia Schultz, born near Prague in 1894, whom he met in April 1920. She will actively support and advise him in the all of his endeavours in the following years. The film project *Dynamics of the Metropolis* takes shape. A manifesto published in the journal *De Stijl* (October 1921), "A Call for an Elementarist Art – to the Artists of the World!", signed by Raoul Hausmann, Hans Arp, Ivan Puni and Moholy-Nagy can be counted among his first important theoretical proclamations. He also works as the Berlin correspondent of the avant-garde journal *MA*, published in Vienna.

1922 After taking part in several group shows, such as those at Fritz Gurlitt's gallery (1920), Moholy-Nagy has his first one-man show at Der Sturm, the Berlin gallery run by Herwarth Walden. He also designs four covers for the gallery's eponymous journal. With Lucia he discovers the photogram, which becomes the crucial medium for his exploration of light. He participates in the Congress of Constructivists and Dadaists in Weimar. He is noticed by Walter Gropius. His first exhibition in an art museum is organised in the Folkwang Museum in Hagen by Ernst Fuhrmann. The *Buch neuer Künstler* is his first publishing project.

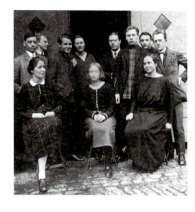

39 Students from the preliminary course with László Moholy-Nagy at the Bauhaus Weimar, 1924/25

40 László Mohly-Nagy, 1925
Photo: Lucia Moholy

41 Group photograph of the Bauhaus masters on the roof os the Bauhaus building in Dessau, 1926; from l. to r.: Josef Albers, Marcel Beuer, Gunta Stölzl, Oskar Schlemmer, Wassily Kandinsky, Walter Gropius, Herbert Bayer, László Moholy-Nagy, Hinnerk Scheper. Photo: Walter Gropius with self-timer

1923 Second exhibition in Berlin at the Der Sturm gallery (with László Péri) in February, with his *Material Construction in Glass and Nickel*. The Kestner-Gesellschaft exhibits his photograms. The first printed examples of his experiments with camera-less photography appear in the American journal *Broom* (no. 4, 1923). In March Moholy-Nagy moves to Weimar, where he is hired by Walter Gropius for the Bauhaus. There he succeeds Johannes Itten in teaching the preliminary course and Paul Klee in leading the metal workshop. Moholy represents, moreover, the new, Constructivist approach as well as the social orientation of the school. The institute's first self-presentation, planned for summer 1923, is largely supervised by Moholy-Nagy. The catalogue designed by him is regarded as an early example of the New Typography.

1924 Moholy-Nagy displays his so-called "Telephone Pictures", industrially manufactured, reproducible works in enamel, at his third exhibition at Der Sturm. He also takes part in the "First German Art Exhibition" in Moscow.

1925 The Bauhaus yields to political pressure and moves to Dessau. The first of ultimately 14 *Bauhausbücher* edited by Gropius and Moholy-Nagy is published; volume 8 (*Malerei Photographie Film* [Painting Photography Film]) presents the foundations of his media theory. Further statements on photography and typography as well as increased involvement in theatre, dance, ballet and stage design. He makes the acquaintance of the Swiss art historian Sigfried Giedion, who will remain a close friend and intellectual companion for the rest of his life. At the same time he takes his first photographs with a camera, including a steep-angled view of a hotel terrace at Belle-Île-en-Mer (fig. 30) – described by Sibyl Moholy as a "completely new beginning": "The camera had never been used this way."

1926 Participates with Piet Mondrian, Wassily Kandinsky and other proponents of non-figurative art in the "Great Berlin Art Exhibition" at the Kronprinzenpalais. In early December the first number of the journal *bauhaus* appears. It includes a major article by Moholy-Nagy, "photography is light design".

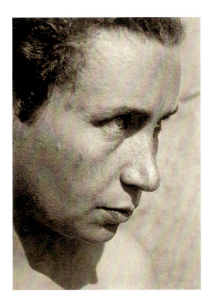

42 Portrait of Lucia Moholy, 1928
Photo: László Moholy-Nagy

43 "Film und Foto" exhibition, 1929
Kunstgewerbemuseum, Berlin

1927 In Berlin Moholy-Nagy meets Kazimir Malevich, whose book *Suprematism – The Non-Objective World* is published in an abridged version as volume 11 of the *Bauhausbücher*. Moholy-Nagy's works are shown in the exhibition "Paths and Directions of Abstract Painting in Europe" in Mannheim.

1928 Walter Gropius leaves the Bauhaus. Herbert Bayer, Marcel Breuer, Xanti Schawinsky and Moholy-Nagy follow suit. The latter returns to Berlin, where he finds success as a stage designer for the Kroll Opera and Piscator Theatre. He experiments with new materials such as rhodoid, neolith, trolith, galalith, silverite and aluminium, which are incorporated in the Space Modulators from the mid-1930s on.

1929 Moholy-Nagy and his wife Lucia separate. His programmatic text *von material zu architektur* [published in English as *The New Vision*] appears as the last of the originally planned 30 titles of the *Bauhausbücher* series. He is represented with no fewer than 97 works (photographs, collages and photograms) at the Stuttgart Werkbund exhibition "Film und Foto" (FiFo), with stations including Stuttgart, Zurich and Berlin (fig. 43). In addition he conceives the controversial "Room 1" for the show. Essentially a school of seeing looking far back into the history of photography, it is regarded as pioneering by contemporaries. He develops the typographic concept for the woman's magazine *die neue linie*, premiered in September, as well as the first of a total of ten covers made principally in collage technique. Acquaintance with Joris Ivens and Dziga Wertow. This is also the key year in Moholy-Nagy's involvement with film.

1930 Moholy-Nagy shows his "Light Prop for an Electric Stage" at the "20th Salon des Artistes Décorateurs Français" in the Grand Palais in Paris. Afterwards he makes the short film *Light Play: Black White Grey*. The programmatic series *Fototek* edited by Franz Roh brings out as its first volume *L. Moholy-Nagy – 60 Fotos*. From the mid-1920s on he travels to Italy, France, Greece, Norway, Finland and Switzerland.

1931 Acquaintance with the actress, film consultant and scriptwriter Sibyl Pietzsch (1903–1971), who later becomes his second wife. Delphic Studios in New York presents the first exhibition of his photographs in the

United States. Together with Herbert Bayer, John Heartfield and Karel Teige, as well as members of the "Ring neue Werbegestalter", Moholy-Nagy takes part in the show "Fotomontage" organised by Cesar Domela.

1932 The Julien Levy Gallery in New York presents 20 photographers living in Germany and France under the title of "Modern European Photography". It includes Man Ray, André Kertész, Lee Miller, Helmar Lerski, Ilse Bing and the former Bauhaus members László Moholy-Nagy, Walter Peterhans, Herbert Bayer, Florence Henri and Umbo.

1933 Participates in the 4th International Congress for Modern Architecture (Congrès International d'architecture Moderne/CIAM) held in Greece with Sigfried Giedion, Le Corbusier, José Luis Sert and other representatives of Architectural Modernism. At the suggestion of Giedion makes a film about the historical event. First attempts in the field of colour photography at the end of the year, which only prove practicable for Moholy-Nagy with the introduction of Kodachrome three-layer colour film in April 1935.

1934 Divorces Lucia, marries Sibyl. Emigrates to Amsterdam. There he works as Art Director for the journal *International Textiles*. Contributes ideas for an exhibition stand for the Dutch artificial silk industry at the Jaarbeurs in Utrecht and at the World Exposition in Brussels. Invited by Willem Sandberg, exhibits in Amsterdam at the Stedelijk Museum at the end of November.

1935 Leaves the Netherlands and founds a design studio in London with his fellow Hungarian and assistant of many years, György Kepes. Designs shop windows for Simpsons of Piccadilly, develops the corporative image of Imperial Airways, creates invitation cards and posters as well as an exhibition stand for the Courtaulds artificial silk factory. Moholy-Nagy also directs films (*Lobsters*, 1935 and *The New Architecture and the London Zoo*, 1936), and supplies visual material for three books illustrated with photographs: *Street Markets of London* (1936), *Eton Portrait* (1937) and *An Oxford University Chest* (1938). Before doing so he switches from an Ernemann camera for 6.5 × 9 cm negatives to a Leica, which allows him to shoot rapidly, unobtrusively and serially.

1937 Recommended by his mentor Walter Gropius, Moholy-Nagy is appointed head of the "School of Design" in Chicago, an institution initiated by the Association of Arts and Industries and modelled on the Bauhaus curriculum. He moves to the United States with his wife Sibyl Moholy-Nagy and their two daughters Hattula (born in 1933) and Claudia (1936–1971). He names the planned exhibition institute "the new bauhaus. American School of Design" and gives a first lecture on the pedagogical programme at the end of September. Four weeks later the school opens in Prairie Avenue with about three dozen students. On 19 June the exhibition *Entartete Kunst* (Degenerate Art) is inaugurated in Munich, defaming the legacy of Modernism and including at least one work by Moholy-Nagy.

1938 Financial difficulties and the growing dissatisfaction of the students lead to the closure of the school. Moholy-Nagy once again turns to commercial jobs, working as graphic artist, designer and consultant, without giving up his vision of a design school in the United States. A Bauhaus exhibition at the Museum of Modern Art (New York) establishes the Bauhaus as a "brand" in the United States.

1939 In February Moholy-Nagy is able to open the private "School of Design" (Ontario Street), thanks to the substantial backing of the Container Corporation of America under Walter P. Paepcke. Instructors include György Kepes and Hin Bredendieck. The curriculum is expanded over the years with the subjects of economics, psychology, biology and war design/camouflage. Moholy-Nagy continues to be active as a painter, photographer and creator of kinetic objects.

1940 The Katharine Kuh Gallery in Chicago hosts a one-man show of his oeuvre. Moholy-Nagy works on 16 mm promotional short films about the teaching at the school with his students. He participates in symposiums and conferences, publishes and plans an overview of his thought and creative work in book form. *Vision in Motion*, however, is first published posthumously only in 1947.

1944 The School of Design is reorganised, becomes a college with an administrative board, and receives a new name, "Institute of Design". At the end of the year it moves to new quarters in State Street.

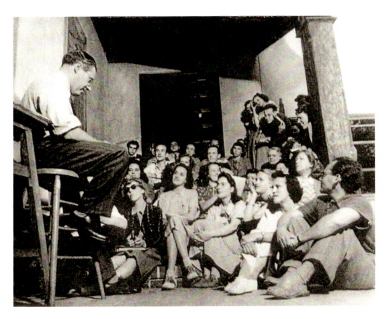

44 László Moholy-Nagy gives his inaugural lecture at the "new bauhaus,
American School of Design", Chicago, autumn 1937

45 László and Sibyl Moholy-Nagy, Somonauk,
Illinois, USA, ca. 1939

1945 Moholy-Nagy is diagnosed with leukaemia at the end of the year. A last intensive creative phase follows, with drawings, watercolours and panel paintings. At the same time he develops his Space Modulators into three-dimensional objects of metal and Plexiglas.

1946 Moholy-Nagy becomes a United States citizen in April. He leads a six-week summer symposium titled "New Vision in Photography" with the photographer Arthur Siegel. The English translation of his 1929 book *von material zu architektur* is published in a third edition as *the new vision – abstract of an artist*. László Moholy-Nagy dies in Chicago of leukaemia on 24 November.

1947 An extensive, commemorative travelling exhibition is shown by the S. R. Guggenheim Foundation in the Museum of Non-Objective Art.

1951 Otto Steinert initiates the rediscovery of the artist in Europe by including photograms by Moholy-Nagy in a type of historical prologue to "subjective photography", the programmatic travelling exhibition he curates and inaugurates in Saarbrücken.

46 László Moholy-Nagy at
Mills College, Oakland, 1940

47 Walter Gropius and László Moholy-Nagy
at the Institute of Design, Chicago, 14 August 1945

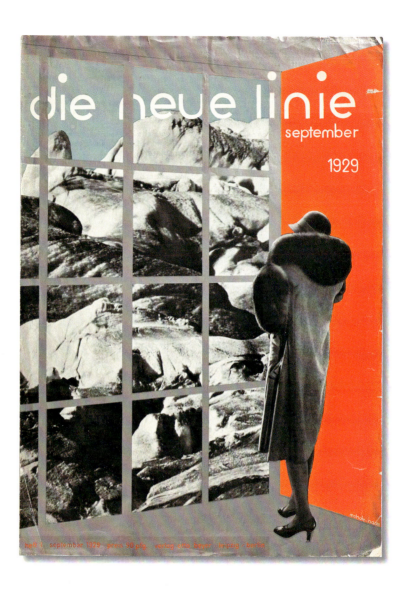

Moholy-Nagy's cover design for the first issue of *die neue linie*.
September 1929

ARCHIVE

Found items, letters, documents
1919–1938

Johannes Itten was responsible for the typographical appearance of the Bauhaus until his departure in 1923, a task later taken over by his successor, Moholy-Nagy. An early example of his pioneering role in the field of the "New Typography" is the catalogue for the first Bauhaus exhibition in Weimar.

The pioneering series of the Bauhausbücher *jointly edited by Walter Gropius and Moholy-Nagy from 1924 was judged retrospectively by Sibyl Moholy-Nagy as perhaps the "most fruitful result" of their friendship. The bulk of the work in bringing out the series of ultimately fourteen books, however, fell to Moholy – with the support of his wife Lucia as editor.*

Volume 8 of the Bauhausbücher *appeared in a print run of 2,000 copies and marked the beginning of Modernism in photography in both theory and practice, a Gesamtkunstwerk in the spirit of Constructivism. Its visionary contents were recognised intuitively by many, but not always entirely understood. A reviewer in the* Photographische Rundschau *remarked in 1926:*

"Whether we are for or against these ideas – not so new, by the way, for the practising filmmaker – examining them will prove fruitful in any case."

The number 60 seems to have particularly fascinated artists and publishers in the interwar years. August Sander had earlier supplied his book Antlitz der Zeit *with the subtitle* 60 Photographs of German People. *Renger-Patzsch followed this concept with* Parklandschaften. 60 Fotos für die Warburgs. *Similarly, the short-lived book series on the photographic avant-garde launched in 1930 used the apparently "magic" number in its title. Designed by the "leading typographer of the century", Jan Tschichold, the first volume appeared in 1930:* L. Moholy-Nagy: 60 Photos. *It was the only publication of his activities in the fields of photography, photogram and photo-collage during his lifetime. Editor Franz Roh wrote in the foreword:*

Ia Inside title page (designed by László Moholy-Nagy) for: *State Bauhaus Weimar 1919–1923*, Bauhausverlag Weimar/Munich

Ib Cover of *Bauhausbücher 8, László Moholy-Nagy, Painting, Photography, Film*, Munich 1925

Ic Cover *Fototek 1*, edited by Franz Roh, Berlin 1930

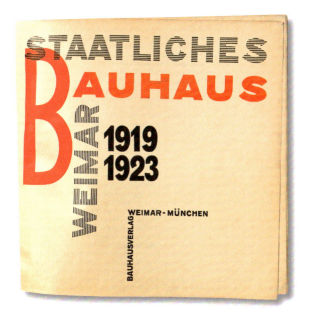

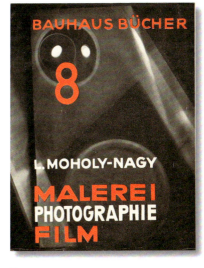

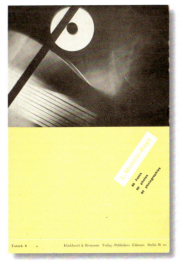

"Moholy-Nagy, a Hungarian who has lived in Germany for several years, has played a decisive role in the history of the *latest photography*. [...] As a painter, Moholy belongs to the 'Constructivists', a group that has pushed the striving for abstraction in today's painting to the utmost, that is, not merely fragmentarily including the objects of the real world, as Expressionism and Cubism desired. Here, only the pure pigment of colour should speak in the organisation of a strictly geometric formal world."

2

The end of his time at the Bauhaus and the move to Berlin meant new tasks for Moholy-Nagy, who was also interested in multi-media: designing opera stage sets first for the Staatsoper am Platz der Republik, better known as the Kroll-Oper, and then for the political theatre of Erwin Piscator.
Tales of Hoffmann *by Jacques Offenbach was premiered at the Kroll-Oper on 12 February 1929. Moholy-Nagy contributed the set design. For this theatre event, regarded as the "staging of the century", the artist had attempted to:*

"create space from light and shadow. [...] Everything is transparent," *stated Moholy,* "and all of the transparencies fuse into a profuse, yet still perceivable structuring of space."

The central component was a screen that floated over the stage and tapered towards the rear, serving as a projection surface for short film sequences. This was a concept energetically opposed by the nationalistic-conservative press, as a review in the Berliner Lokal-Anzeiger *(13 February 1929) shows:*

"And to rob the Dr Miracle scene of any effect, laughable snippets of film are stupidly projected on the skewed ceiling of the attic."

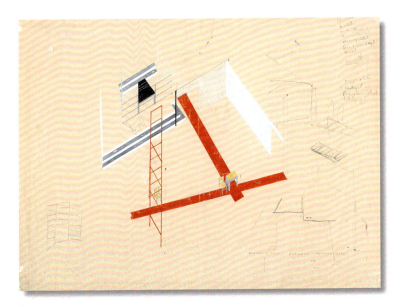

2a

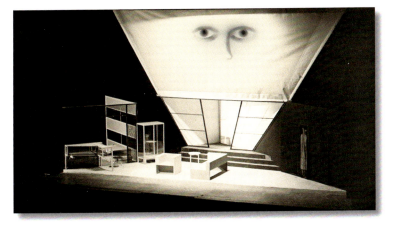

2b

2a Set design for *Tales of Hoffmann* (1st act Olympia), 1928, mixed media
2b Stage set for *Tales of Hoffmann*, Kroll-Oper Berlin, 1929, photo-collage
by Lucia Moholy

3

On the initiative of the Association of Arts and Industries, an organisation for the promotion of industrial design comparable to the German Werkbund, the New Bauhaus – American School of Design was founded in Chicago in 1937 with Moholy-Nagy as its first director. In spite of substantial problems, not least financial ones, and several re-structurings and re-namings (as the Institute of Design in 1944, for example), the former Bauhaus master was able to demonstrate his pedagogical talent here again until his death.

The offer of reviving the Bauhaus concept in the United States was seen as "a splendid idea" by Walter Gropius. In a letter to the Association of Arts and Industries from 18 May 1937 he recommended his former employee Moholy-Nagy as a possible director:

"He is the best man you can get, has had very wide experience and is endowed with that rare creative power which stimulates the students."

Moholy described the first school year in an extensive letter to Gropius from 8 June 1938, including a conflict that arose around the issue of "free" art. A section of the students considered the Bauhaus as a "community of free artists" and based this perception on a supposed statement by Gropius, who had "described something like this".

"[…] the majority of students have, I believe, produced excellent results in all the subjects. But already during the first semester a few older students, most of them painters, formed a group and claimed to follow your statement mentioned above. They stayed away from various classes, claiming that they had to follow their inner voice and paint. They conducted propaganda against the Bauhaus goals as a design school among the other, mostly younger, students, proclaiming that the objective of our training can only be the free artist. It is an impudence, they claim, to require prac-

3a László Moholy-Nagy, *the new bauhaus*, 1937, cover of the first school brochure

3b Advertisement for *The New Bauhaus*, from: *Architectural Forum*, October 1937

tical work from an artist, even the design of a poster is degrading. This was a difficult situation. I consider myself above all a painter and I know the value of a free practice of art. […] I introduced modelling, which in addition to the scientific work functioned as an emotional outlet for the students. […] <u>I am convinced, namely, that we and especially I overestimated the technical-scientific side in our training between 1920 and 1930 and that the reciprocal interaction of the three disciplines of art, science and technology has to be given greater consideration.</u>"

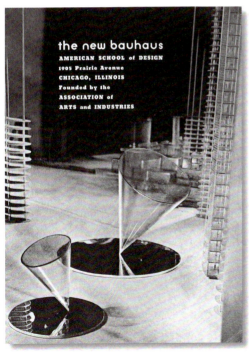

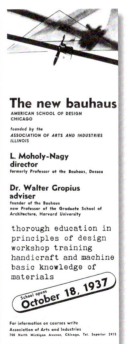

3a

3b

SOURCES

—
PHOTO CREDITS

The originals were graciously provided by the museums and collections named in the captions or were supplied from the archives of the publisher or by (numbers are page numbers):

akg-images: 8, 15, 19–22, 24, 26, 36, 49, 61 below
ARTOTHEK: 10
ARTOTHEK – Museum Folkwang Essen: 42, 47
Bauhaus-Archiv, Berlin: 28
bpk: 61 centre, 63 below
bpk/CNAC MNAM/László Moholy-Nagy: 29, 40
bpk/The Metropolitan Museum of Art/László Moholy-Nagy: 39
bpk/The Art Institute of Chicago/ Art Resource, NY: 34, 51
bpk/CNAC-MNAM/Georges Meguerditchian: 18
bpk/Los Angeles County Museum of Art/Art Resource, NY/László Moholy-Nagy: 37
Bridgeman Images: 14, 59
Busch-Reisinger Museum: 25
Courtesy of the George Eastman Museum, Rochester: 23, 33

—
TEXT EXCERPTS HAVE BEEN TAKEN FROM THE FOLLOWING PUBLICATIONS:

(see also the notes on pp. 54/55)

Sibyl Moholy-Nagy, *Laszlo Moholy-Nagy. Ein Totalexperiment*, Mainz/Berlin 1972: 72
Das A und O des Bauhauses, Leipzig 1995: 72
L. Moholy-Nagy. 60 Fotos, Berlin 1930: 74
Oliva María Rubio (Hg.), *László Moholy-Nagy. Kunst des Lichts*, München 2010: 74
Berliner Lokal-Anzeiger, Berlin, no. 75, 13.2.1929: 74
Peter Hahn/Lloyd C. Engelbrecht, *50 Jahre new bauhaus*, Berlin 1987: 76

Published by
Hirmer Verlag GmbH
Bayerstraße 57–59
80335 Munich
Germany

Cover illustration: *The City's Lights* (detail),
1926, see page 33
Double page 2/3: *Composition A XXI* (detail),
1925, see page 26
Double page 4/5: *Climbing in the Mast* (detail),
1928, see page 38

www.hirmerpublishers.com

TRANSLATION
David Sánchez, Cano (Madrid)

COPY-EDITING/PROOFREADING
Jane Michael, Munich

PROJECT MANAGEMENT
Tanja Bokelmann, Munich

DESIGN/TYPESETTING
Rainald Schwarz, Munich

PRE-PRESS/REPRO
Reproline mediateam GmbH, Munich

PRINTING/BINDING
Passavia Druckservice GmbH & Co. KG, Passau

Bibliographic information published by the
Deutsche Nationalbibliothek
The Deutsche Nationalbibliothek lists this
publication in the Deutsche Nationalbibliografie;
detailed bibliographic data are available on the
Internet at http://dnb.dnb.de.

ISBN 978-3-7774-3403-2

Printed in Germany

———●———

THE GREAT MASTERS OF ART SERIES

ALREADY PUBLISHED

WILLEM DE KOONING
978-3-7774-3073-7

LYONEL FEININGER
978-3-7774-2974-8

PAUL GAUGUIN
978-3-7774-2854-3

RICHARD GERSTL
978-3-7774-2622-8

JOHANNES ITTEN
978-3-7774-3172-7

VASILY KANDINSKY
978-3-7774-2759-1

ERNST LUDWIG KIRCHNER
978-3-7774-2958-8

HENRI MATISSE
978-3-7774-2848-2

PAULA MODERSOHN-BECKER
978-3-7774-3489-6

LÁSZLÓ MOHOLY-NAGY
978-3-7774-3403-2

KOLOMAN MOSER
978-3-7774-3072-0

ALFONS MUCHA
978-3-7774-3488-9

EMIL NOLDE
978-3-7774-2774-4

PABLO PICASSO
978-3-7774-2757-7

EGON SCHIELE
978-3-7774-2852-9

VINCENT VAN GOGH
978-3-7774-2758-4

MARIANNE VON WEREFKIN
978-3-7774-3306-6

www.hirmerpublishers.com